Ayatana

Edwin Thumboo

I

Installation

Ayatana	7
Epiphany in SG	11
Fullerton Building A	13
Fullerton Building B	16
Singapore River Front, 1958	18
Singapore River	20
Singapore River: missing paintings	24
An Ancient Town in Western Hunan	28
Running Stream	29
Dancing Mutants	31
The Tyger	32
Minimalist	34
Chief Executive Offiers	39
NGS Staff	41
Hang a Painting: 10 For 1	42
NGS Building	44
Cultural Medallion	46
The Other Wall	49
Brushes	50

II

Assemblage

National Language Class	54
Liu Kang at 90	59
The Charity Lady I	61
The Charity Lady II	64
Yeo Landscapes	67
Expressing Ubin	68

I

Installation

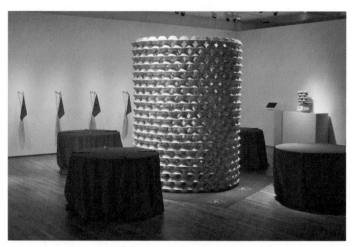

Montien Boonma. *The Pleasure of Being, Crying, Dying and Eating.*
1993, reconstructed 2015. Ceramic bowls, wooden tables, cloth and brass; 255 x 180 x 180 cm.
Collection of Singapore Art Museum. Installation view at *Between Declarations and Dreams: Art of Southeast Asia since the 19th Century*, a permanent exhibition at National Gallery Singapore.

Ayatana[i] (for Leen & Mark)

I

This Path begins within our senses. Alert, curious,
cumulative, they garner domains, yours and mine,
reality to dream, folding all into the over-arching sixth.[ii]
This intelligence sorts out journeys; tabulates; grades;
essentialises; pegs, reveals, and instructs. It broadens,
reads shadows beneath the rose, the auguries locked
in a heron's poise, the ways of Self and World, minding
us to meditate, in soft moments, the amplitudes of
birth, growth, appetite, then death.

Joy and sorrow, love and loss, prune and prime us till we
see light exhale radiance. Then we know white, pink, red
lotuses are purity, devotion, and the rise to heaven. Those
who grew under Boh and Banyan, gave mantras, ordained
prayers to touch others. *Om mane padme hum*,[iii] in void
deck, hermitage, bead and key-pad. Chants shape paths,
map philosophies. Insert signposts. This one reads *The
Pleasure of Being, Crying, Dying and Eating*.[iv]

Basic. Universal.

II

Montien, who suffered double death by cancer,
distilled new art whose currents circulate and
bloom between these key signifiers and signified,
 to
strip, bare, invert. Symbols in familiar colours
pair, ignoring almanacs of custom and tradition.
They shock and shake by blunt interphase. Chopsticks
are bronzed finger bones. Sides of bowls host beigey
lower jaws fired into them, then laid smartly on red
clothed table. Re-proportioned, post-dying fragments
grace sapu tangans ready for dinners. Atop bowl-tower,
a yard of pink intestine gleams with mucus. A final
counter-point: decay and auspiciousness, compacted
without remit, trading places to alternate their impact.

We share bone, sinew and flesh, we SG Melayu,
China, Kling, Serani. Demolish fish-head curry,
take the Pledge, celebrate each other's Festivals.
We keep ancestry, identity, major and minor feelings.
Above all, live our Faith, Belief, words of Divinity.
They infuse our senses, all six, to cope with the ebb
and flow, mulling this swirling apology of a world.
 For me, the Beatitudes, and His gift of
 Bread and Wine at the Last Supper.

Feb 2018, Phoenix Walk,
668121

8

[i] "Āyatana [...] is a Buddhist term that has been translated as 'sense base,' 'sense-media' or 'sense sphere.' In Buddhism, there are six *internal* sense base (also known as 'organs,' 'gates,' 'doors,' 'powers' or 'roots') and six *external* sense bases (or 'sense objects'; also known as or 'domains'). Thus, there are six internal-external (organ-object) pairs of sense bases." Wikipedia, s.v. "Āyatana," last modified 15 September 2019, 18:43, https://en.wikipedia.org/wiki/Ayatana (accessed 16 September 2019).

[ii] The sixth sense is "mind," our central processing unit, memory bank, etc. See ibid.: "Buddhism and other Indian epistemologies identify six 'senses' as opposed to the Western identification of five. In Buddhism, 'mind' denotes an internal sense organ which interacts with sense objects that include sense impressions, feelings, perceptions and volition."

[iii] "The first word [...] *Om* is a sacred syllable found in Indian religions. The word *Mani* means 'jewel' or 'bead,' *Padme* is the 'lotus flower' (the Buddhist sacred flower), and *Hum* represents the spirit of enlightenment." Wikipedia, s.v. "Om mani padme hum," last modified 20 July 2019, 09:18, https://en.wikipedia.org/wiki/Om_mani_padme_hum (accessed 16 September 2019).

[iv] The title of Montien's installation. See National Gallery Singapore, "The Pleasure of Being, Crying, Dying and Eating," Artworks, https://www.nationalgallery.sg/artworks/artwork-detail/1996-00216/the-pleasure-of-being-crying-dying-and-eating (accessed 16 September 2019). This comment on another Montien installation *Lotus Sound* is especially apt: it "juxtaposes the idea of permanence and transience, solidity and fragility, traditional symbolism in Buddhism and contemporary art language of minimalism." "About the Artists: Montien Boonma," Asia Society, https://asiasociety.org/hong-kong/exhibitions/transforming-minds-buddhism-art (accessed 16 September 2019).

Like most influential, innovative artists, Montien had students. Navin Rawanchaikul was a disciple who was close to him, his "Dearest Montien, A Tribute to Montien Boonma" discusses Montien's main ideas and has neat phrasing that sum that up. See Art Asia Pacific, http://artasiapacific.com/Magazine/89/DearestMontiendiscusses (accessed 16 September 2019).

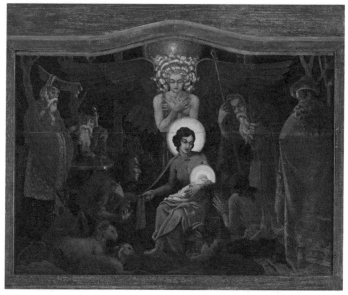

Richard Walker. *Epiphany.*
1942. Oil on wood panel, 71 x 98.6 cm.
Gift of Rev Dr Moses Tay.

Epiphany in SG[i] (for Mariel)

You chose, my Lord, a manger,
That lowliest place of all,
Arriving in the grip of winter,
To redeem us from the Fall.

See, Infinite Love adored, worshiped
By humble shepherd to the triple wise.
Frame together-stories, much retold
In art, in song, as we re-contextualise

This double-love, in familiar images, their
Concord shaped by the power of Your grace.
Faith had quickly spread. The Jordan Dove[ii]
Soared and flew through time and space.

> By coming here
> The Spirit takes us there,
> To still waters.

Gaze and meditate. The walls dissolve,
Leaving purity, colour, radiant light
Around the Advent of our Saviour,
Who lifts us morning, noon and night.

Wisely knowing, three journeyed from afar.
Braving ice and fire, pushed by certainty,
Skirting hazards and Herod's sinful cunning,
They carried gifts for Your Nativity.

(cont'd)

See Mary frocked in neat-stitched blue;
Joseph his quiet, usual self. Sheep and goats;
Adoring shepherd; girl in joyous wonder;
Figures from our ancestry, in familiar coats.

An angel, golden curled, hands folded,
Wings firmly spread, guards our Lord.
In the yearly spinning of the world,
This season, surely, is sanctified by God.

 Mother, and Child.

Our Lord,

 Our Christ,

 Our Saviour,

Hallowed,

 Loving,

 Pure,

 Perfect,

Now, forevermore, ever, Amen.

[i] Richard Walker's *Epiphany* conflates The Nativity and The Epiphany, which explains why there is an angel, shepherd, sheep and the three Magi. Apart from this, the painting is notable for putting the main figures in an Asian setting, dressed accordingly.

[ii] John the Baptist felt unworthy to baptise Jesus but did so, thus fulfilling prophecy. He says: "I saw the Spirit descending from heaven like a dove, and it abode upon him [...] he that sent me to baptize with water, the same said unto me, Upon whom thou shalt see the Spirit descending, and remaining on him, the same is he which baptizeth with the Holy Ghost." John 1:32–33, King James Version.

Fullerton Building A

Before he became a building a hundred years later,
Robert F was Straits Settlements' chief honcho,
remembered for inventing Municipalities. He died
young. A brief sadness, an admin hiccup. No loss
of presence; no lessening of C-drive. C for colonial.

Raffles' child grew rapidly, expanding around
these parts. A little up, where the river broadens
into a carp's belly, Chinese merchants flourished.
A Chulia village commenced nearby. Across busying
waters, *Rule, Britannia! Britannia, rule the waves!*

She knew the power of monuments, anniversaries,
Birthday Hons, ceremonial pomp: Nelson's Column,
The Albert Mem, KCMGs, the Delhi Durbar. In SG,
Vic Mem Hall, The Municipality, The Supreme Court.
These flags, emblems, dress parades, were visible ritual.

PM LKY addressed white-collared English-eds. They
were slow in feeling nation. He spoke with passionate
conviction, of what we could be, must be. The Way
Ahead. *Pull together; get going; move.* At his fiery best.[1]
He gripped packed crowds with argument and passion.

 Fullerton transplants.
C structures and customs are worth appraising. Pick with
finesse. Refurbish; join them into new grandeur. Their
halls, corridors and alcoves brighten hopes and dreams.
Ours. They breathe new reality; seven star pulsations.

Names blend to unify; narratives settle into history.

12–16, 27 Mar 2019

[1] Ong Sor Fern, "GE2015: A Look Back at Election Rallies in the Heart of the
City Including the Fullerton Rally," The Straits Times, 7 September 2015,
https://www.straitstimes.com/politics/ge2015-a-look-back-at-election-rallies-
in-the-heart-of-the-city-including-the-fullerton (accessed 17 September 2019).

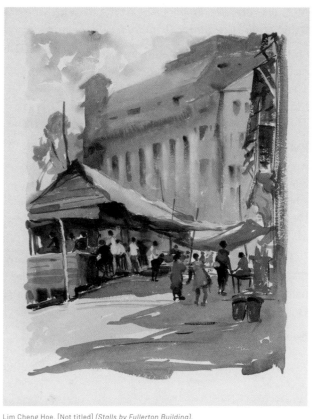

Lim Cheng Hoe. [Not titled] *(Stalls by Fullerton Building)*.
Watercolour on paper, 50 x 40 cm.
Collection of the artist's family.

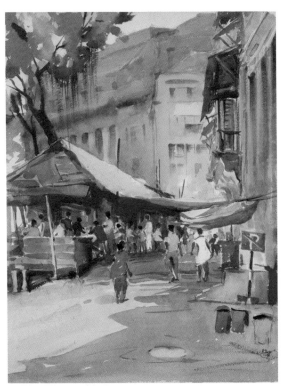

Lim Cheng Hoe. [Not titled] *(Stalls under Tree by Fullerton Building)*.
Undated. Watercolour on paper, 53 x 39.8 cm.
Collection of the artist's family.

Fullerton Building B

(by Lim Cheng Hoe)

Two paintings of a scene is intimate affection. Minor
variations. Less light. Or a passing cloud. The tarpaulin
consistently dubious white. In one, the tree is stripped.
In the other, a No Parking sign; possibly minor progress.
Talk of one is talk of two. I love both. So do others.

Your 4th floor was my first work-home. Fifty-five months
I income taxed, scrutinising account books, balance sheets,
invoices, not poems, treaties, or concepts. No satisfaction,
after years studying literature, history and philosophy,
learning how words sing of us; we the crown of things.

Real life was outside. Lunch breaks, very special. Then
we were ourselves, for a brief hour, among folks like us,
catching up with friends. Especially uni mates. We never
lost our anti-colonial fever, and remembered peninsular
dreams, as growing politics taught, mobilised, sowed seeds.

Looking at you, Fullerton B, I look at myself; at memories.
They crowd, ruminate, talk. Pause. Some want a second life.
Behind your paintings' ordination, was our world. Us. We.
A fermenting mutual familiarity, a blossoming C-M-I; a
camaraderie; an ease of sharing jokes, umbrellas, teh-halia.

We walked and talked the scene you paint, sat at that stall.
And those to the right, where your brush did not go. Eating
mee rebus, char kway teow, prata, hokkien mee, nasi lemak,
prawn-beef-fish ball mee, soup kambeng, abolong, dosai.
Kalvinators of orange crush, sasi, Green Spot. Ice-kachang.

No ang mohs. We ate; they dined, at the SCC. By then, our
politics had started pushing against colonial divides. The drive
for control of time, place, our destiny, gathered under David
M's old apple tree. He rallied desire into conviction, appealing,
inter alia, to 'agile fence sitters' to join our fight for ownership.

Yards across, in F Square, pressure to rouse and forge the nation
escalated. Roused, crowds joined Merdeka calls. Pro-Brit skeptics
worried about communalists and communists. We knew better,
having debated ideologies, power games, stereotype racism—
long hair was bad etc— and other issues. We were moving.

Our togetherness fanned pork-less pedas BBQs. Friendships
grew. I shared what I had learnt over years, for coming times.

Not all party leaders were clear, comprehensive and convincing.
LKY stood out. Did not mince his words. Spoke to the point.

Logic of common sense, sharp forensic analysis, his oratory,
gave purpose. Galvanised. Changed the mood of lunch crowds.
Many took away those moments, and their mood. They saw a future,
felt hope.

Poems should know when to stop. Thank you, Lim Cheng Hoe.
Your work pulls life and contacts into each painting. For those
who shared that flow, memories return, circulate in the light of
our minds. They renew themselves, and us, in ways none else can,
then retire, waiting for another moment to refresh again.

1–6 Apr 2019

Singapore River Front, 1958

Contemplate from mid-river. Absorb,
with sense and memory. Recall narratives.

We are there, post-lunch office mates, idle
by the steps, thinking of ice-kachang and bubu
chacha. Noor rubs his stomach as Kok Wah tooth-
picks a pair of gold-clad teeth. Too late, Samy says,
remembering Casey, that so-and-so slave-driver
who loves surprise checks at 2.01 precisely.

These two edifices confronting us, had Chinese
neighbours. Built by merchants. For here the waters
broaden into a carp's belly. Auspicious for business,
which grew, attracting poor clansmen from China's
southern coasts. Laboured, stared at hardship, survived
the grind, making home from home, our Chinatown.

Across, the CSO,[1] Vic Hall fronted by Stanford R, his
bronze arms folded; the Supreme Court, and the SCC,
for Whites only. Colonial eminence holding sway. Till
David M began ours, the Peoples', earnestly, under
the old apple tree. Loud and clear, his triple Merdekas
shook foundations as they invaded velvet corridors.

Meanwhile, those milling bumboats, load unload;
link Outer Roads and godowns. Kept life flowing
before the container's new efficiency. Years later,
the great clean up.[2] Now a place for joy, notably River
Hongbao.

 Yet nothing gladdens the heart more when,
work done, you sit by water's edge, as full moon
lays a path of shimmering gold to wash your feet.

Mar 2019

[1] Colonial Secretary's Office, home to the chief administrator of the colony.

[2] See Yugal Kishore Joshi, Cecilia Tortajada & Asit K. Biswas, "Cleaning of the Singapore River and Kallang Basin in Singapore: Human and Environmental Dimensions," Ambio 41, no. 7 (Nov 2012): 777–81, https://www.ncbi.nlm.nih.gov/pmc/articles/PMC3472009/ (accessed March 2019).

Singapore River

(for Genevieve)

You have seen me, time and again, in painting,
sketch, and passing glance. Taken photos. Smelt.
Having lived long, mixing with other destinies,
I have many tales. These, sedikit, are for today.
 So listen.

When the final thaw released me from that
in extremis ice-age grip, I rose to claim my
banks. Palm and mangrove. Bush and creeper
flower daily; sparkle and irradiate; garnish
pockets of shade. Bees buzz pollinate. Pristine
streams murmur among rocks, glide over brown
pebbles. Fish dart here and there, past crab
and shrimp. Light and shade, too, play hide and
seek on shimmering waters. As otters gambol
in their favorite cove, elephant, tiger, deer, black
panther and boar, come to drink. Most vivid is
Kingfisher's royal plunge. The flurry of feathers
transforms into widening ripples, fading silently. A
soft merging, as when salty waves enter my mouth.

 Everything in rhythm, in season.

Orang Laut, and more, settle, slash and burn; trap
and harvest. A quiet life.
 Then they came in ocean
ships from western shores. Driven by appetite;
less by soul. Extended explosive, global empires.
How they used, abused and maimed. Filth. Decay.
My slow dying. These I try to forget. But not, never,
that recent great clean up, the husbandry and after care.

Look at me today.
My banks are architecture, start-ups, discos, eateries;
munching in converted quays, where fusion juggles
classic hawker food. A yen for yuan. Museums, bars.
What tourists love away from home.
 And governance-
planning for the future's promise and uncertainty.
Attract those we want, yet keep it first for SGians.
They stroll, Grandpa in wheelchair; cyclists, in twos,
maneuver adroitly. The careful flower beds and shrubs
are pleasures of a Garden City.

Flowing into these Barrage still waters, I have little rise
and fall. Yet cannot help but give. With Rochor and Kallang,
 now as tidy, we feed a new lake, gradually salt free.
 Her dreams out do mine, as I await they who
 Love me with their eyes, capture me
 in paint, ink, and now, gizmos,
 for more
 Art.

 Mar–Apr 2019

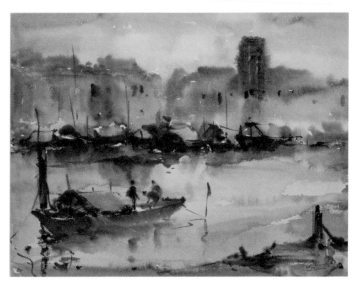

Lim Cheng Hoe. *Singapore River.*
1962. Watercolour on paper, 37.8 x 50.5 cm.

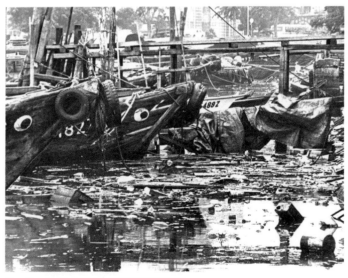

View of tongkangs crowded upon the Singapore River.
Ng Cheng Kiat Collection, courtesy of National Archives of Singapore.

Singapore River:
missing paintings

I

Old photos cannot lie. Each
is an aide memoire for me
to unlock drops of memory;
details pop up more readily.

They stir. I see, I smell; a bend in
the flow, tapering sad, dark waters
which, depending on wayward winds,
are stinky, stinkier, or stinkiest.

No dumping...By order...Port A...
at a most convenient spot,
was openly cool temptation.

II

Soon overfed banks grew: mattresses, split
cupboards, smashed rickshaws, broken jars,
dubious beds, fractured dreams, piled high.
Spiced by garbage, oil spills, sewage, maggots,
they clogged, brewed a terrible rich cocktail,
turned bubbly by our cheerful noon-day sun.

Worst, when monsoons flooded farms dotting
the river's catchment, livestock drowned.
Dead pigs, poultry, the occasional cow, floated
down tributaries. They bloated; got stuck. A
feast for resident rats. Special aroma alright!

Across, not far off, a tongkang graveyard. Only
the ribs left, held together by keels buried
deep in mud. Their fine, dense grains, don't
allow hard woods to die easily.

You grumbled if you lived within nose distance,
got used to it, somehow, while anticipating HDB's
arrival, hopefully soon, sooner, or soonest.

7–10 Mar 2019

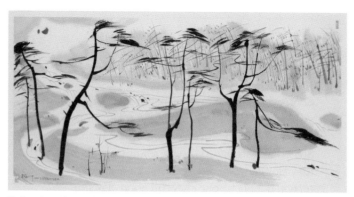

Wu Guanzhong. *Running Stream.*
1988. Chinese ink and colour on paper, 69 x 138.2 cm.
Gift of Dr and Mrs Ho Kee Hang.

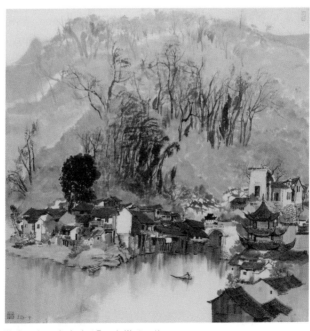

Wu Guanzhong. *An Ancient Town in Western Hunan.*
1980. Chinese ink and colour on paper, 103.2 x 103.8 cm.
Collection of Wijono T., Singapore.

An Ancient Town in Western Hunan

(for Jia Yun)

Key brush strokes shade us to-and-from black-
and-white. Chinese surely, this ink, this paper.
They rise from a corner of quiet waters, whose
serenity flows into clusters of buildings. As eyes
observe, see and gather more, pick each detail.
A bridge across dividing stream. It rises quickly,
diminishing into low hills as houses turn smaller.
Perhaps a pool, behind the crossing, has boats.

The town grew, obeying undulations of the land;
adapted to its rise and fall; the slopes; unusual views.
And what the changing seasons thought is best for
unity of scene, people, place. Close to waters; away
from it. They varied. Balanced. See that looming
central edifice. One enormous door. No windows.
Neat defense, no less. Then houses by the shore.
Peaceful. Only a pair of oars in early leftish breeze.

Further up, the trees in clusters. Black but moving
Into lighter gray, as the scene spreads, as the rise
gains light. The Wu touch is there: little red, green,
and thin, transparent brownish touch. They must be
there, *in situ*, when he feels his best, to draw you,
then release you. Breathe what you see, you feel,
you touch, until you know its streets and slopes,
are filled by it and therefore, ready to depart,

from your Town in Western Hunan.

Running Stream

Because you travelled other traditions,
chiefly French, but kept your own in words,
form, colour, strokes, shades of their deeper
ambience, we have these moments. They speak.

Here the stream, pushed by hills further up,
is pulled in speed by drops miles far down.
So quiet as it hurries. A rich simplicity
growing arduously. Through shades of grey,
Black and White move into each other. One
colour whose opposites frame the scene.

Levelness broadens flow. Notice the trees
on each bank. They differ. Distant ones are
straight. There are four mud-bank islands,
a few rocks, perhaps more beyond the right.

Absorb carefully. Little red and green dots on
both sides. The green ampler, among the leaves.
Subsidiary. Potent. Bright. Life in a barren
Landscape which counts. It will soon thrive,
perhaps, when Art turns into enlarging pulse
blossoming in rich, returning seasons.

You are many painters, Wu Guanzhong.
Each occasion picks the one it needs.
Give plainness a higher speech as
We read a special painting. QED.

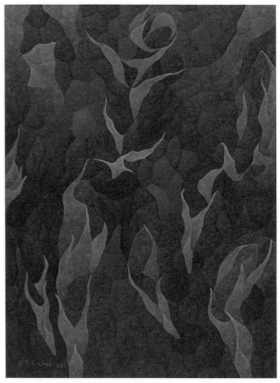

Hernando R. Ocampo. *Dancing Mutants.*
1965. Oil on canvas, 101.8 x 76.0 cm.

Dancing Mutants (H R Ocampo, 1965)

Brighter than a thousand suns, *I am become
Death.*[1] Yet, as atoms split, re-configure, they
sometimes moderate to re-arrange the glories
in the bud, the splendours of the bush. Under
a cleansing Heaven, life re-blooms, charged
and changed through a quiet, through that self-
propelling spirit, within us since our islands' birth.

Find us, the children of ancestral soil. Fertile
to the fingers; mother of sturdy bread. See how out-
stretched arms and legs, taut in mutated greens,
glow steady under mushroom clouds. Red hot rocks
cool into semi-browns. Sublime are garden colours,
detoxing the air we breathe. Neighbours in this frame,
I take their comfort into my heart to un-crust, re-new.

You abjure incineration. Hope now splices love. Peace
 Conjugates forgiveness. Colour. shade and shape
 counter war and pain;
 take away their sting.

 Thank you,
 Ocampo San.
 You made me see. Seeing, think.
 Thinking opened doors
 To myself and others.

 May your tribe increase.[2]

2–10 Mar 2019

[1] A line—perhaps the best known—from the *Bhagavad Gita* that ran through
Robert Oppenheimer's head when he witnessed the first nuclear explosion on
16 July 1945. It should be taken in context as Lord Shiva is also the Creator.
See James Temperton, "'Now I Am Become Death, the Destroyer of Worlds'.
The Story of Oppenheimer's Infamous Quote," Wired, https://www.wired.co.uk/
article/manhattan-project-robert-oppenheimer (accessed 16 September 2019).

[2] Based on the opening line of Leigh Hunt's poem "Abou Ben Adhem."

The Tyger

Tyger Tyger, burning bright,
Stripes ablaze with inner light,
In the forests of the night;
In corners of the Milky Way?
What immortal hand or eye,
That knew the powers of the sky,
Could frame thy fearful symmetry?
Or let you keep immortal sway?

In what distant deeps or skies.
Or furnace lit by silent cries,
Burnt the fire of thine eyes?
No, nor any power shun
On what wings dare aspire?
Or what paws that dare not tire,
What the hand, dare seize the fire?
Or stoke the furnace of the Sun?

And what shoulder, & what art,
What blazing glory, and what part,
Could twist the sinews of thy heart?
And when the glory of thy shift,
And when thy heart began to beat,
What loud music of thy heat?
What dread hand? & what dread feet?
What dread magic thy eye could lift?

What the hammer? what the chain,
What the axe? What mischief train?
In what furnace was thy brain?
In what fire was anger raised?
What the anvil? What dread grasp,
In what template, with what rasp,
Dare its deadly terrors clasp!
Dare its deadly terror hazed!

When the stars threw down their spears,
And twinkled less in what appears,
And water'd heaven with their tears.
Did he feel his work to know?
Did he smile his work to see?
Or expect it better, twice, to be?
Did he who made the Lamb make thee?
Did He expect it twice to grow?

Tyger Tyger burning bright,
As your Eternity grew in might,
In the forests of the night?
What memorial shift or deep;
What immortal hand or eye,
Touch the gripping of your thigh,
Dare frame thy fearful symmetry?
Or the edges of your sleep?

MINIMALIST... (for Elaine Ee)

Space-Light-Object.[1]

Behind,
issues of origins, practice-cum-aesthetics bracing this
company of subtly incremental chimes, incomplete
cubes, strings trailing shadows, oblong black-pimpled
monotone board, four seemingly inconsequential rocks,
and more, each carefully conceived, is *art*. This diversity
harbours possibilities. They surface when beholders get
allured enough to ruminate imaginatively. Journeys start
from this conjunction, this intersection of tone, variety of
form-substance, audacious simplicity, negation of closure.

Explore,
no confining here, no frames, no converging point.
Grammar shifts: play *of* colours is now *with* colour,
whose intensities, soft to solid, tune impact. Note how
space devises geometry. More materials, less ecstasy
of pigment. But, above all, people are *absent*, sent to ride
imagination to fortify the self's intuition. Soar together.
Dip and stir, then sketch, indifferently, in our mind's eye,
adding to Wen Hsi gibbons or Peng Seng's *Construction*.
A secret artist, walking and stopping for an hour or so.

Unhung,
such compositions are mixed. But that is not the point. They
morph as we move, tilt heads, re-focus. Created by potencies
quarried below alter-egos. Unknown to others, they glow
briefly, remain quintessentially private. We grasp this flow,
use make-shift calligraphy. Pushing. We learn. A cup, lone
on the table, is not drink or loneliness, but *conversation*.
Obeying line and angle, boxes journey to places we chose.
Such acts of completion, modest in the larger judgment,
enrich our art-response. The ordinary becomes more.

 So does life.

 1 Feb 2019

[1] *Minimalism: Space. Light. Object.*, the title of the first exhibition in Southeast
Asia to focus on Minimalism, 16 November 2018–14 April 2019, National
Gallery Singapore.

One subject of Minimalist art is the observer, namely the aggregate of what
he-she experiences—what is seen, felt, accepted and rejected, and more—
all melding into significances that ultimately influence the doors of perception.
Some are moved to take the experience further.

Kim Lim. *Intervals I plus II.*
1973. Pine; 4 parts, each 183 x 22.5 x 2.5 cm.

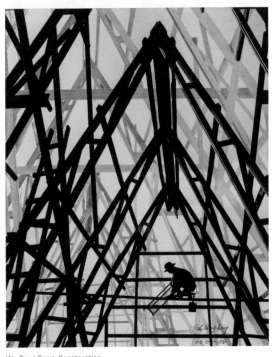

Wu Peng Seng. *Construction.*
1958. Gelatin silver print, 49.5 x 40 cm.

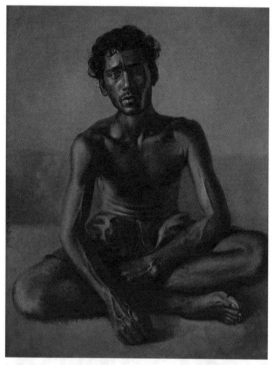

Chua Mia Tee. *Road Construction Worker.*
1955. Oil on canvas, 86 x 66 cm.
This work of art has been adopted by Seah Cheng San and
Chong Siak Ching.

Chief Executive Officers

(for Chong Siak Ching)

As the ladder gets higher, the more we
juggle power. A sad necessity, in these days
of '*I first*' elbowing, tricky KPIs, flashy share-
options, rich exits. All this is harrowing when
you cleave to Word, Soul, Spirit, Heart; keep
principle and pulse; inhabit a house of light.

There are various paths to goodness.
For some, His commands. They mould:
This above all: to thine own self be true,
And it must follow, as the night the day,
Thou canst not then be false to any man.[i]
Truth has no expiry date. No matter where,

its strength and inference, from priests, wise
friends, parents, siblings, a blooming flower, to
image-galleries, wait to be absorbed. Supremely
articulate, calculi of photo and painting uplift
while pleasing. As in these two, one engineered
by lines, the other a man whose body, tensed
by years of labour, speak our founding history.

We enter them. They us. Stir dialogue, adjusting
to mood, to tone, to footsteps exploring surprising
byways in our mind, as colours stalk imagination.

That is what you are about.

Milling richness snaps into vivid affirmation,
a moment that is Art. Yet the finished work can't
be foreseen. Know its fullness only when it arrives.

(cont'd)

In *Construction*, ingenuity overcomes woody limitations by a geometry of angled struts. A carpenter, from whom all radiates, is can-do Chinese energy. Beams in black, shading into greys, against white, articulate the play of light. His hand saw, plus the few tools in his canvas bag, served all seasons; built homes or crafted rare blackwood cabinets. He is still busy. SG does not sleep, instead dreams of the next reality. *Nil Sine Labore.*

This, our *Road Construction Worker*, knows. Co-ordinates of limbs, veins on arms, full folded knees, squared shoulders, a day-end pair of eyes, signify staminered resolve. Saw him, those years ago, resurfacing Newton Circus. Our early roads grew from such as he. They left family, ancestral village in the Madras Presidency, far away. Now chant to lighten tasks. These specialists elided bends, steam-rolled mud-tracks, laid hard surfaces, mostly puddle free.

There is no end to treasures you custodian with Grace and Love to maxi-share with young and old. All who gaze. Your vision enriches Time and Space with SG themes and Great Gallery exhibits.

You are behind NGS. Behind you a Mountain. His patient rainbow watches over you, your all. Coziness and cherishing: they make every end an amber framed beginning.

Sept–Oct 2018

[i] William Shakespeare, *Hamlet*, 1.3.78–82.

NGS Staff

Something special in their manner.
I felt it early, that envelopment with
many aspects of their work, especially
those entirely theirs. They knew their part,
their share, their air, their primary touch.

When taking you through an exhibition.
a gallery or installation, they had facts,
but greater, feeling. Especially of central
pieces. Systematic, yet open to lively talk,
getting you gradually into what you saw.

They take you in by telling, by opening moods
of colour, form, ways a moving figure spreads
lively motion. As she explains, what you see—
contemplate, begins to speak, to tell you of itself,
start a link. It grows. You feel at home in it.

You continue into fresh insights, a bit here,
another there, as you engage, lose contact
as you respond to what is before you, finding
an intriguing patch of shades, a surprising eye
watching, as it tries to work out your language.

Move on to her next cameo. Add to learning
about another painting. Artist, title, place and date
put it into our history. Questions have raised
themselves. We move faster. At the end I thank
her as she leaves and remember Zhen Min and
her Team, the first of those who started this.

Hang a Painting: 10 For 1

(for Zhen Min &
all exhibition staff)

We see, admire; enter without distraction.
Find holiness of contact. It grows, in ways
We don't expect, imagine or decide ourselves.

Curator, Project Manager, Registrar know
Their cue; do what's required so all can move
Ahead. They share their labours, so others know
The mood of contact. Of them, who is good, sincere?
Helpful or distrusting? Better to know and meet them
Accordingly. That is how the team keeps pace.
Remember, others in the ten, and beyond, are on tap.
Feel free and easy to ask, discuss, find what you want.

Conservator, Artwork Manager and two Art Work
Handlers. The painting. To ensure its safety, its
Blessed wholeness to ensure, its appurtenance, quiet
Ambience and so on. They know far more than us
Who come to a perfect installed piece we consume
How we can. They do their professional bit, Perfect.
Each does to self satisfaction, they know in surety how
The moving finger writes, then moves on.

The Exhibition Manager, Lightening Technician.
Designer, They too have their chores, equal in subtlety,
In angle, shade and poise. Every painting asks
For its own frame to parcel and please, be part
Of its moment, quiet, heaving or in throes.
And the light that brings the colours out, or shades
Them in, are surely crucial. A flaming red too soft,
Or demanding, can distract. Paint to stir thinking.

No more, no less.
They give what is ours,

They work, mostly alone. We do not see them
As they too, admire and breathe what's done.
In the end, that admire, and watch the paintings
That we see and contemplate, alone.

NGS Building

I

The Supreme Court and Municipal Building.
Each had first histories: side by side, their
own functions were law and order, and services
keeping us a healthy colony. Fronting the Padang
surrounded by a road, shaded along its South by
trees, it was for high events. The Municipal steps
were excellent for Lord Mountbatten as he arrived
for General Itagaki when the Japs surrendered.
Displays. Parades. Celebrations. And many of
SG's National Days since 1966.

Grand appearance of British Imperial power in
this Civic District was key. The MB, 1929, was a major
start: eighteen three-story fluted Corinthian columns
topped with a wide cornice was enriched by four corner
pavilions and a central balcony was a recesses porch
for heavy bronze doors. Vic Memorial Hall-Theatre,
the SCC and Parliament would be demolished for
a large, new Treasury. Only the Court was built.
The Treasury stopped by WWII, perhaps forever.

The S Court too was classical, designed by the Chief
Architect, PWD. As the edifice of the Civil District,
it had the grounds of the Grand Hotel de l'Europe
which closed in 1932. The times were: difficult:
the Great Depression, the rapid rise of Hitler's
Germany and the threat of Japan at in the Far East.
Yet the appearance of British power and authority,
Emulating London's Old Bailey Courthouse.

II

S\$532 million turn MB and SC into NGS. Now,
finally, a fresh beauty; on the inside. True gift to our
Nation, ASEAN and the World. Partly higher betterment.
A growth in Spirit this gift of brushes, chiefly. Ways of the
Arts. Our new promotion. A high graceful point in PM Lee's
2005 Nat Day Rally Speech for SG to be 'a place where
people want to live, work, and play, where they are stimulated
to be active, to be creative and to enjoy life.'[i] So this Gallery,
whose paintings, programmers, and special exhibitions, well
mounted all-round, are constantly thoughtful and provocative.

You consider, think, feel, re-compute, enter what you see.
When you come again, some paintings, or parts of displays,
call you. Converse, speak better, and stimulate questions as
you move, hesitate or pause. Galleries apportion their space
for permanent collections of national, regional, special themes,
the work of great seminal artists, based on policies, aims and
overall aims. Each year has its rhythms in each major section,
DBS Singapore Gallery, UOB Southeast Asian Gallery,
the Keppel Centre for Art Education, Singtel Special Exhibition
Gallery, Ng Teng Fong Roof Garden Gallery. And the Padang

Atrium is for poetry readings, the crowd sitting on the steps.
For this is the place where the arts flourish and link, and flip,
and join. Words and paintings, then the music of Gan's flute,
at times a guitar. From art to Art, arising through floors,
galleries, longish exhibits, the return of old installations
like Montien's round tower of bowls and their stark
embellishments. The names are many, taking us across
time and space, to link, appropriate, invent, create distance
and familiarity, more and more, till we return again,
to Art and Artefact and finally to Ourselves. Om and Amen.

[i] Quoted in Lim Shujuan, Sushma Goh & Marc Nair, eds. *The Making of National Gallery Singapore* (Singapore: National Gallery Singapore, 2015), 40.

Cultural Medallion

Not all six first Awardees knew each other
Well. OTC, later DPM, who loved all Arts—
The great, bright heart of Nations—knew it was
Time to push, promote, recognise and tilt. So began
High support, across genres, in our four Cultures.
Their amply rich divergences, a tough prospect.
Our challenge was towards something special:
A fresh nuance, a soft excitement from them for us.

Each had done, performed. Sharpened leaps of words,
Tuned thought and movement, empowered notes, all
Into narratives, neat releases. Craft was raised above
Itself. They added themselves incrementally, to better
Our Art. Surely, more than new. For we gradually took,
From our three Others, placing their gifts among
Those we grew up with. Primal selves had intimate
Offers whose pulse and breath we shared and brewed.

Multi-ethnic, we knew the unity to build for solidarity.
To shape and wear, to ply into our identity, mine Tamil-
Teochew. A making, a mix and match I saw emerging
In singularities out of our hyphenated origins. Self-SG-rean.
Our variety is infinite; immense. Many coming after us
Give as freely; create as we still do. But more. Progress
Is massive. Technology pervades. Little is untouched.
With AI and the digital; all fully supported.

We are global too; of the First World on many counts.
The Straits Times is replete with multiple reports of how
We modernise. And the burgeoning colours regaling us!
They augment what Asia and Europe and Africa had.
Now, from poetry to digit painting, the Rainbow moves,
Vibrates, heaves and stops, in every handphone and TV.
We are there, with all the World offers, with SG ingenuity,
Sharing what we have.

Aug 2019

This poem was commissioned by the National Arts Council to commemorate
40 years of the Cultural Medallion, the highest artistic accolade in Singapore.

Children enjoying the woodblocks at the installation *The Other Wall* by Nge Lay and Aung Ko, commissioned for *Gallery Children's Biennale 2019* at National Gallery Singapore.

The Other Wall

(by Aung Ko & Nge Lay)

I am Sundram. My younger sister Meena is seven.
She is with Amma. Appa drove, and parked
downstairs. He got tickets for the Children's Biennale
which Tim, my classmate, said was very good,
especially the OORT CLOUD AND THE BLUE
MOUNTAIN. They called, excited you, playing
with colours, sounds and other things. Gripped.

We got the big-white multi-coloured brochure.

Appa works with computers. He goes to Chennai,
Kolkata, Yangon, and a big city in China. I have
A small machine which I can use. Not as good as his.
I am too young to go with him. And there is school. Here
we went to each event, from B 1 to Level 1. At number
5 I played longer with Appa's help. I learnt more. Then
DAYUNG SAMPAN again. It won the *Children in
Museums Award* last year. Goody! My favourite.

Too much excitement. Appa knew, as we reached the two
small Myanmar huts, in Supreme Court Foyer. Neat and tidy
and empty. I stopped in the one with tales for me to read
and take copies; to keep and give away. One must be for
Tim. He may have it already. But I can keep the extra.
Looking at sketches and reading the stories was fun. They
Were about Kings, Queens, poor people. The ladies a bit
mixed. Chose the one you like. Not easy, but must try.
Money Graber; he who never forgets his humble origins.

There were more. *Mr Hatred; Nandathu, the young King;
The Boy who drew Cats; the rich couple.* Everyone had a tale.
I understood, at times after re-reading. They were like those
Amma and Appa told us some evenings, as we sat in the
verandah after dinner. Amma had more which were gentle,
loving and forgiving. Now I have new ones to tell them,
and to Meena, of course.

Brushes

Each tradition has its store. What we
have is thus infinite, from delicate to
large. And some artists make their own,
for special needs. So pick those that fit.
Take two, oil and canvas, ink and paper.
Remember how cleverness in hand and
fingers, work their will, as they apply,
depict, grow vision into painting.

Oil and canvas. You need distance, finally,
to enjoy the finished form, the icon. *Mona
Lisa* or *Dancing Mutants*. They ask for time,
to invent their unique approach. First a big
composition. Then small improvements, by
eliding further colours; a wee touch; looked
at carefully, from many points, pleasing to
hold roving eyes searching for what's new.

Ink and paper. The approach is not the same.
Here is speed; accuracy. Almost no re-doing.
None. A shading from black to white, or white
to black. Their shades are colours. Their Chinese
masters who also trained in Europe, at times
added little patched of red, green and brown.
This is where the Gallery needs more, to fill
and balance the spaces of our tribes.

Neat and many, our brushes wait.

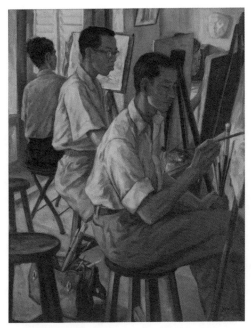

Lim Yew Kuan. *Painting Class.*
1957. Oil on canvas, 83 x 65 cm.

II

Assemblage

National Language Class

Because history and geo-politics sustained
One irredentist Nusantara pulse, especially
Its lingual nerve, we sing our national anthem
In Bahasa which has bits of other tongues some
Fifty generations took, ingesting script, word,
Grammar and poetics to enrich shairs, pantuns,
Proverbs. It can be swift as Hang Tuah's blade,
Yet ululate *dongdang sayang's* rare sweet-
Sadness, lift court and kampong; grace adat.
Satu Bangsa, Satu Agama, Satu Bahasa. Add
 Satu Negara.

So we schooled. See the dark left canvas patch
Light towards multi-racial faces, each intently
Focussed on this brown Nanyang voice that still
Harangues regional moments, neighbourly loud;
Yet it raised ringing slogans for 12 million hopes.
Spot Jawi etched faintly on the blackboard. Note
Chegu, text in hand, encouraging his pupils,
Testing each the other on what's just learnt.
 But
All this changed, in post-Merger anger, angsts,
Unfriendly gestures. That grinding aftermath
 Marred it all.

Our prodigal Little Red Dot and all in her—cut off
And cast upon bitter tides, turbulent seas—lived
Precariously. We re-started bare, small and mixed;
Mitigated; sought moorings for our migrant peoples,
Cultures, orthodoxies, prejudices.
 So our founding
Fathers strategised: three pillars, best free marketing,
Socio-economic growing; rising GDP and Surpluses;
Semi-socialist means of sharing gains; educate; unite;
Shift mentalities; our languages for roots, English
To bridge, its spurs to globalise, as we, advancing,
 Sing and celebrate
 Majulah Singapura.

Mar–May 2014

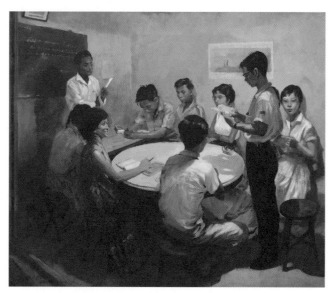

Chua Mia Tee. *National Language Class*.
1959. Oil on canvas, 112 x 153 cm.

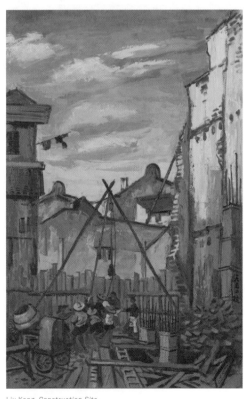

Liu Kang. *Construction Site*.
1950. Oil on canvas, 126.5 x 85.5 cm.
Gift of the artist's family.

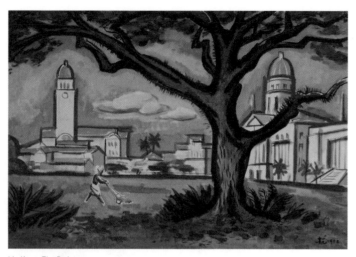

Liu Kang. *The Padang.*
1952. Oil on canvas, 86.6 x 127 cm.
Gift of the artist's family.

Liu Kang at 90

An artist and his model; an outdoor class
Of friends in search of life, and self, across
Traditions, inherited forms; a lady with easel:
Sure capture of poise, glow, and taut stillness.

Surely your brush learnt from the heart;
The heart from a secret pulse; the eye from
The moving breath of history. All with a spirit
You kept forceful, supplely anchored in true light.
A journey of many beginnings, as when you took
Matisse and his friends, gradually making
Their gifts Asian, as when they nestled into our
Earth and water and air. Helped you paint
Chinese seasons; then our island rhythms.
Especially Bali, which some say is a navel
Of the world, a place of definition, of pilgrimage.

Your art travelled, quintessential, then came
To us, its inter-continental colours vivid with
Memory: **Hock Lam Street** 1951 98 x 131 cm—
That is where we celebrated with char kway teow;
Thai beef balls; Ah Lau's Alphonso mangoes.
 The Padang 1952 127 x 86 cm—
That is where we memorialised Lim Boh Seng;
Re-made mistaken destiny; celebrate National Day.
You paint history from the inside, giving
Images, whose power, the meditated moment,
Makes them circle and climb to explode in us.

(cont'd)

No scene you frame is without man; or woman;
Or roads and houses. We meet fruit sellers;
Mid-autumn filled with pomelos and lanterns.
Were there peach blossoms? Silence by a lake?
All life is one for you, who fathom, touch, temper
The root and heart and essence of all things. So
You mastered stroke, colour, shade, texture;
The density of space; the clarity of blurred detail;
Till the whole exceeds the sum of parts. So
One orchid is as precious as a happy village. So
We gaze on mask and face, receding hills,
 The many poles of your world,
 Learning how life too,
 Measures all,
 And, through
 Your Art,
 Life.

29 Apr 2000,
Westin Stamford

The Charity Lady I

Look, and take serene intensity. It invokes,
gathers and grows, pure as the sparkling,
rolling drops of condensed dew on broad yam
leaves. I hear each face and pairing hands utter
burdens, deeper knowing in augmented light,
as they share conjunctive blessing. See that
middle, in extremis. Hidden is the inflicting
cold, for his bones have travelled. Behind
soft propping pillows, a lad's sad warmth.
Like Grandpa's last hours again. And Mother,
and Child, that presence of boundless Love,
modernised, ever constant, re-ignites the Spirit.
Theirs and yours and mine and all who behold,
as that anxious wife, on knees, who supplicates,
as the nun intones, thinking of final mercies.

(cont'd)

Know Brethren, especially after His finality,
God is love, without beginning, without end...
that ye also love one another as Christ does.
He multiplied loaves, fishes; called Lazarus
forth, drove out unclean spirits, spoke parables
and gave us Beatitudes. Washed disciples' feet;
broke Last Supper bread. The Good Shepherd
who cherished...all ye who labour...are heavy
laden...then let them nail His life upon the Cross,
where He gave them and me and you and all
four corners, His last earthly breath...It is done[1]...
from which flows Faith and Hope, and Christ-like
Charity. For in giving with true hearts we touch
His garment's hem, feel His spirit move in us,
as we share a brother's, and a sister's burden.

See the painting yet again. My eyes know more,
Not what's new but that the heart hoarded, bit by bit,
As missed kindnesses, now steadfast in returning.

29 May 2014

[1] John 13:35, King James Version.

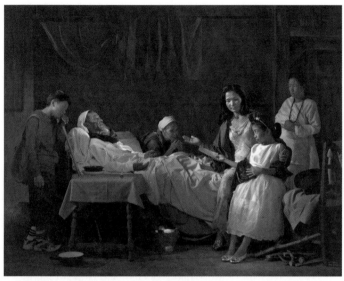

Wong Hoy Cheong. *The Charity Lady* (After Jean-Baptiste Greuze's
La Dame de Charite, 1775) from *the Days of Our Lives series.*
2009. Digital photograph on coated canvas, 83 x 112 cm.
Collection of Singapore Art Museum.

The Charity Lady II

Putting
you side by side with Greuze's *The Lady of Charity*,
your 18th century twin, I see, as expected, its chosen
figures, six in all. All twelve radiate grace and favour
of pastoral light. But his rooted *where* and *what* is
re-contextualised. As people they differ: his French;
yours ex-colonials. Lavantine? The native Other, now
with faces restored and centre placed. No more labouring
in fields of cane, no hot gold mines, no dropping down
on knuckles and knees, levelling their backs for Hidalgos
to mount, attack and blaze up more villages and towns.

Instead,
an update: poised, frail dignity, receiving a young heart's
catechism, coming into peace amidst soft silk and satin, royal
blue, Reebok sneakers, while hands of Faith and Hope in silent
prayer s-m-s ample gravitas that carry the fullest giving only
the blessed know. These are ours. They had trod on us, deleting
our identity. Journeys back to selves still push counter-statements:
sing, paint, write to burn back into Lisbon, Hague, Plymouth,
Paris, adding verbs of correction beyond them, to gird the world,
tuning this century into ours. I wrote years ago of an Asian tide
that sings such power into my dreaming side; how Father's
anger turns my cause.

Nations
rise again as the Other sheds anonymity. We own names, each
a door to the past for us to see our fuller selves, to link and meld
old and new.
Some touched that warmth of light.
So remember please, high
love has no single place, no ordinary history. Ripens in virtues, each
pulse ever itself, no more, no less, as Raja Rao admonished gently
long ago. Primal, nourishing, they are the whole of just action. Their
embrace is everywhere, obeying time, place, tradition, custom, belief;
each tribe's moral grammar. In our Little Red Dot of many faiths and
creeds, world trends and fads assail with grapple hooks, as we hear
the kentong, drum, flute, cymbal, halleluiah call to us.

We share
beliefs but give them different names and forms. Here they
converse, exchange and harmonise like nowhere else,
cementing an over-arching togetherness
of ten faiths, their colours,
shapes, and words.

Thomas Yeo. *Red Earth*.
1992. Acrylic on canvas, 122 x 122 cm.
Collection of Singapore Art Museum.

Yeo Landscapes

For you, dear Thomas, colour
And shape are lyrical, discreet.
Nature's shifting calculi of skies
Accosting hills, echoes along
Attentive valleys, up Interlacing
Slopes, enriching the nuance
Of a waterfall before it reaches
Silence in a pool.

The prospect turns and tightens:
A red tree, a dozen brown-green
In conclave, still, yet speaking
To the eye of memory, and place.
Dawn mists a golden sunrise,
Transmuting and transmuted.

Man, woman, child are always
There, secure, but gently middle
Ground. A hut in the wilderness
Dispenses Iridescence that feeds
The heart; Bold, vibrating blues;
A somnolent boat on crystal
Waters; the noons of light.

Feel again an ancient boon, you
Who gaze upon each landscape,
A lore; mandamus sigh of leaves
Protecting you from city goblins
On the march among sensualities
Of raw ambition, of heaving, cash;
Unattended, selfish pride.

Abstracts have their essence;
The real deepens both of us,
As rainbows move your art.

Expressing Ubin

(for Ho Chee Lick)

I

No four seasons here, only sun and moon
Embracing hill and shade. Such markers
Set boundaries and tell a tale. For instance,
Most footpaths shimmer and sweat at noon.
That's when children scurry to the beach.
A tall tree, with long hippy branches, ruminates.
A special spot where, some say, playful spirits laugh,
Punctually, at twelve on Thursday nights.

Across, is that other island, where once a lion,
By his shore, stared at a Raja in his boat,
One of many beginnings, many heaving moments,
Transcribed: in sajara, hikkayat, those passagings
Between Dragon's Teeth; a Raffles' Settlement
And that Farquah man. Colonial longings filled.

Then uncertainty before growth to a steady,
 Cool prosperity.

City, you have gained, but have misplaced

 The sea's quiet.

II

Here, you still tell, as life goes on,
When the monsoons shift, or what
The rolling thunder says; why the day
Burns without mercy, or what the bloody
Setting sun foretells; when the evening
Speaks unto itself, nightjar and owl vigorously
Converse; why the winds fold up and sigh,
Or the waterfowl stumbles on the lily pads;
When the tide will rise, in peace or anger,
When fish, slit and drying, will taste good.

A knowing across generations; through
Gnarled fingers; cracked, furrowed face;
A moving between sea and land,
Earth and sky, as force and fate.

III

Your enter colour; you hand, wrist, fingers
Ready for scenes to come. Your brushes gather
Shade and hue, Add and subtract a drop of light.
A twist of yellow and blue and green and brown;
Coax a curve of mangrove, then a pair of eyes
To animate this boat's high prow, watchful
Of waves breaking white upon clustered rocks.

Moving inland,

A temple, red and lucky, altogether bright,
Awake and guarding, beyond which a school.
Here a window you open for us to wonder
About the folks within. There a strutting rooster,
His fussy hens and chicks scratching outside
The sprawling, untidy comfort of a crowed home.
Two dreaming cats feasting on fish without dispute.
A hermit-hut on precarious stilts lit by a dab of light.
Then, bare trees, mute calligraphy, spread against
Deep pulsations of an evening sky. You move.

Yet you do not move

Out of grandeur. There is much to see, behold
And ponder, as you sweep the island, full brushed,
Colours primed, as we wait to take them home.

Born in Singapore in 1933, Edwin Thumboo is Emeritus Professor, Department of English Language and Literature, National University of Singapore. He was previously Dean, Faculty of Arts and Social Sciences (1980–1991) and Director Centre for the Arts (1993–2005), and also held Visiting Professorships in the UK, America, Austria, Australia and elsewhere. His poetry includes *Rib of Earth* (1956), *Gods Can Die* (1977), *Ulysses by the Merlion* (1979), *A Third Map* (1993), *Still Travelling* (2008), *Best of Edwin Thumboo* (2012), *Word-Gate* (2013) and *A Gathering of Themes* (2018). He has received the Singapore Cultural Medallion (1980), the ASEAN Cultural and Communication Award in Literature (1987), the Raja Rao Award (2002) and the Meritorious Service Medal Singapore (2006).

The poems in this volume arose out of his visits to the following exhibitions at National Gallery Singapore:

Awakenings: Art in Society in Asia, 1960s–1990s,
14 June–15 September 2019.

Between Declarations and Dreams: Art of Southeast Asia since the 19th Century, a long-term exhibition.

Gallery Children's Biennale 2019,
25 May–29 December 2019.

Lim Cheng Hoe: Painting Singapore,
2 August 2018–5 January 2020.

Minimalism: Space. Light. Object.,
16 November 2018–14 April 2019.

Siapa Nama Kamu?: Art in Singapore since the 19th Century, a long-term exhibition.

Wu Guanzhong: Expressions of Pen & Palette,
31 August 2018–29 September 2019.

Published in 2019.

Please direct all enquiries to the publisher at:
 National Gallery Singapore
 1 St Andrew's Road
 #01-01
 Singapore 178957

Managing Editor: Elaine Ee
Project Editor: Genevieve Ng
Designer: Madeline Lim

The quotes that open and close this book were taken from the author's comments during a roundtable discussion "Painting and Poetry into Installation," held at National Gallery Singapore on 25 May 2019. Full excerpts of this discussion may be found on the Gallery's magazine Perspectives at https://www.nationalgallery.sg/blog.

Image credits:
14, 15: © family of Lim Cheng Hoe.
27: © family of Wu Guanzhong; courtesy of Wijono T., Singapore.
37: courtesy of family of Wu Peng Seng.
47: courtesy of the National Arts Council.

National Library Board, Singapore Cataloguing in Publication Data
Name: Thumboo, Edwin, 1933- | National Gallery Singapore, publisher.
Title: Ayatana / Edwin Thumboo.
Description: Singapore : National Gallery Singapore, 2019.
Series: Words on art.
Identifiers: OCN 1122587009 | ISBN 978-981-14-2215-7 (paperback)
Subjects: LCSH: Ekphrasis. | Singapore--Poetry. | Singapore--In art--Poetry.
Classification: DDC S821--dc23

Printed in Singapore

I think in the end you have to
believe in what you like, and
you must have reasons for
what you like. We all have
our own favourite paintings.

And in fact, the cover
of my book of poems
A Gathering of Themes
is something done by
my grandson when he
was eight years old.

I've enlarged it for the book
and for me, it's an important
thing because I like the colours
there, I like the long, terrible
tail he gave it, and I kept
everything. They wanted to
cut the tail, but I said no!
Don't cut the tail. You let it
get to the edge of the book.

Art speaks differently all the time to different people. I'm afraid to look at the old paintings that I liked, because they don't mean the same thing now. This is part of the greatness of art—that it moves. It changes and it fits you.